ANIMAL FUN

BY KATHY ROSS

Illustrated by Sharon Hawkins Vargo

The Millbrook Press Brookfield, Connecticut

For my good friends Sammy and Hannah!—kr

To Mary Vargo and in memory of Gene Vargo, for all the FUN times at the cabin.—sv

Play-Doh is a registered trademark of Hasbro identifying its quality modeling compound and is used with permission of Hasbro, Inc., Pawtucket, RI.

Published by The Millbrook Press, Inc.
2 Old New Milford Road
Brookfield, Connecticut 06804
www.millbrookpress.com

Text copyright © 2002 by Kathy Ross
Illustrations © 2002 by Sharon Vargo
Printed in Hong Kong
5 4 3 2 1 (lib. bdg.)
5 4 3 2 1 (trade)

Library of Congress Cataloging-in-Publication Data
Ross, Kathy (Katharine Reynolds), 1948-
Play-Doh animal fun / by Kathy Ross ; illustrated by Sharon Hawkins Vargo.
p. cm.
Summary: Instructions for making twenty simple clay-based projects with animal themes.
ISBN 0-7613-2506-9 (lib. bdg.) – ISBN 0-7613-1549-7 (trade)
Polymer clay craft—Juvenile literature. 2. Animal sculpture—Juvenile literature. [1. Clay modeling. 2. Handicraft.] I. Title: Animal fun. II. Vargo, Sharon Hawkins, ill. III. Title.
TT297 .R65 2002 731.4'2—dc21 2001032960

Contents

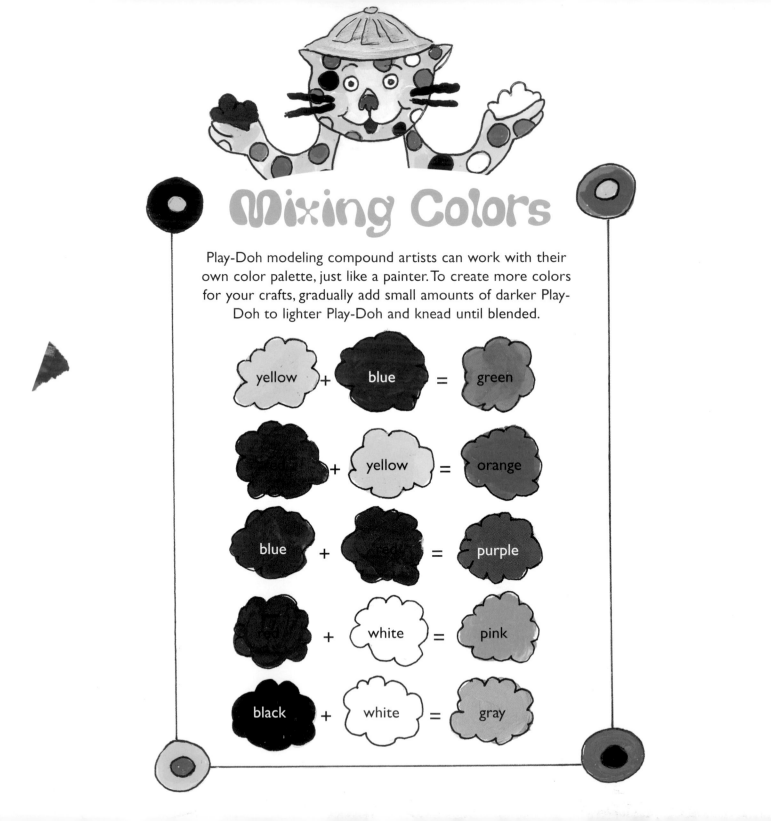

Mixing Colors

Play-Doh modeling compound artists can work with their own color palette, just like a painter. To create more colors for your crafts, gradually add small amounts of darker Play-Doh to lighter Play-Doh and knead until blended.

yellow + blue = green

red + yellow = orange

blue + red = purple

red + white = pink

black + white = gray

Introduction

Generations of children have enhanced their creativity and imagination by playing with Play-Doh modeling compound. This book offers an opportunity to continue that tradition while at the same time adding to their knowledge of the animal kingdom.

Play-Doh, a few simple craft items, and some household materials are all that are required for children to see for themselves some of the more fascinating aspects of animal behavior. For example, the **Porcupine and Dog Incident!** shows what happens when a porcupine is threatened. The **Changing Coat Snowshoe Hare** demonstrates the concept of animal camouflage as the model changes from its winter coat to its summer coat. The **Busy Bee** shows how a bee pollinates flowers. There are 20 such hands-on projects, each designed to reinforce lower elementary school curriculum units on animals.

I've suggested specific colors for each project, limiting the palette to just five shades for practical reasons. But if you have a good supply of Play-Doh on hand, encourage some creativity. To nurture that wonderful curiosity and enthusiasm that young children have about learning new things, just get out the Play-Doh and have a great time!

Kathy Ross

The cockroach is one fast little bug!

black and white Play-Doh modeling compound

Scurrying Cockroach

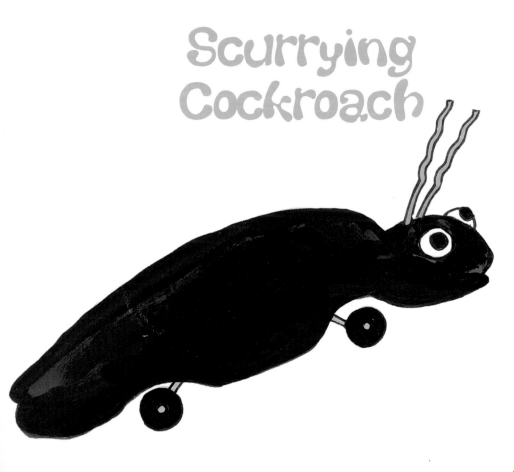

Here is what you do:

1. Flatten out a ball of black Play-Doh. Cover the top of the toy car with the black Play-Doh to make the cockroach. Use the safety scissors to trim away the excess Play-Doh, making sure to cut it away from the wheels so that they will turn smoothly.

 Play-Doh

small toy car

safety scissors

twist tie

2. Press the small balls of white Play-Doh into the front of the car for eyes. Add a small black Play-Doh dot to the center of each eye.

3. Roll the paper edges of the twist tie and bend it to make antennae for the cockroach. Press the curve of the twist tie into the dough above the eyes.

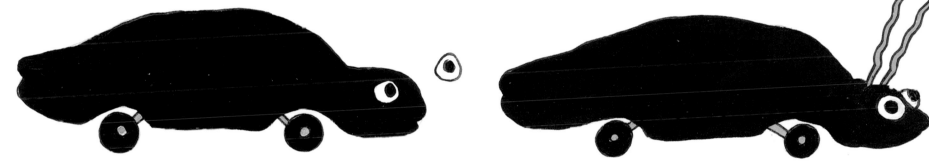

Make two scurrying cockroaches and have a race.

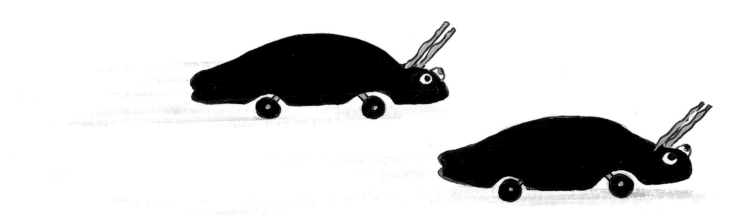

A heavy rain will bring the worms up from the ground.

Here is what you need:

ruler

Worm in the Ground Puppet

Here is what you do:

1. To make the worm, wrap about 3 inches (8 cm) of the bending end of the flexible straw in orange Play-Doh.

2. Make a tiny ball of black Play-Doh and press it into the end of the worm for a mouth.

8

plastic flexible straw

orange and black Play-Doh modeling compound

Play-Doh

Play-Doh

pencil

paper cup

cellophane grass

3. Use the pencil to poke a hole in the bottom of the paper cup.

4. Put the end of the straw down through the hole in the cup so that the worm is inside the cup.

5. Tuck some cellophane grass in the cup around the worm.

Push on the end of the straw to make the worm come up out of the grass. Roll the straw between your fingers to turn the worm from side to side. Watch out for hungry birds!

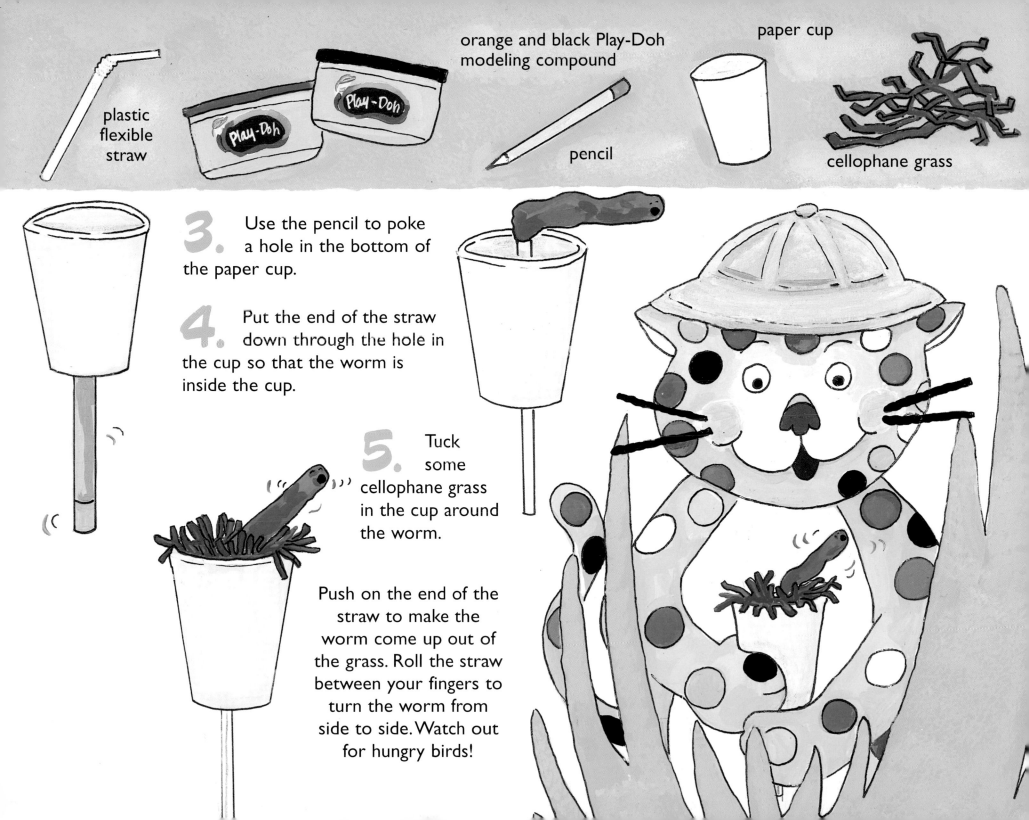

Flower pollen sticks to the fuzzy legs of the bees, enabling the pollen to be carried to other flowers. This is called pollination and is very important work because it brings about new flowers.

Here is what you need:

ruler

three artificial flowers

Busy Bee

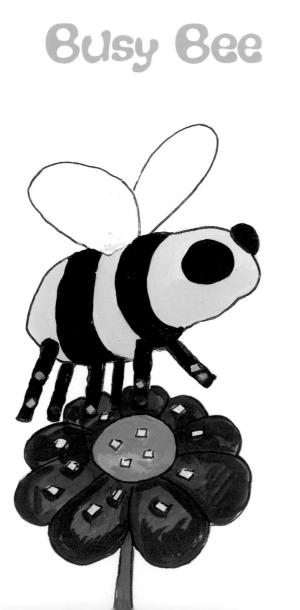

Here is what you do:

1. Roll a ball of yellow Play-Doh about the size of a large marble. Squeeze it slightly to make an oval shape for the body of the bee.

2. Roll two tiny balls of black Play-Doh for eyes for the bee. Press the eyes into one end of the oval body.

3. Roll some thin ropes of black Play-Doh. Press the ropes on the top of the body to make black stripes on the bee.

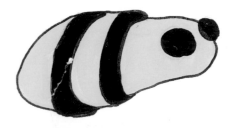

yellow and black Play-Doh modeling compound

black plastic pipe cleaner

safety scissors

pencil

cellophane tape

glitter in three different colors

4. Cut six 1-inch (2.5-cm) pieces of pipe cleaner for the legs of the bee. Stick three legs in each side of the bottom of the bee.

5. Fold a 3-inch (8-cm) piece of cellophane tape in half, sticky sides together. Cut two wings from the cellophane tape. Press the end of each wing into the back of the bee with the pencil.

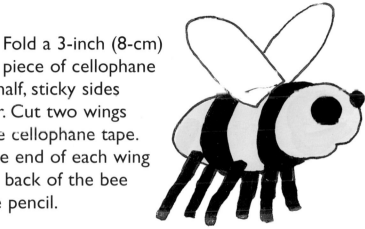

6. Stand each artificial flower in a ball of Play-Doh to make a garden for the bee.

7. Sprinkle a small amount of a different color glitter into the center of each flower.

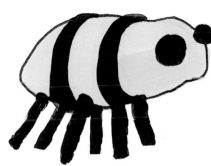

As you fly the bee from flower to flower the glitter will stick to the fuzzy pipe cleaner legs of the bee. When the bee lands in a different flower, some of the glitter will drop off. This is easy to see happening with the three different colors of glitter. What a fun way to show how a bee helps to pollinate the flowers.

Symmetry is when both sides of something are exactly the same. A butterfly is a beautiful example of symmetry in nature.

old discarded compact with plastic mirror

Compact Butterfly

Here is what you do:

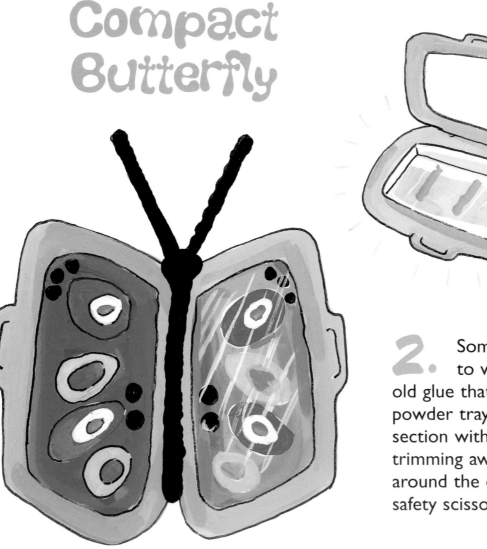

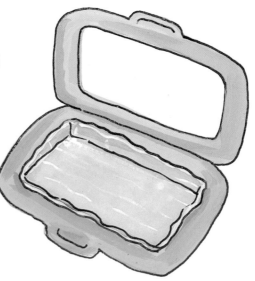

1. Ask a grown-up to remove the old powder tray from the compact for you. Clean the compact.

2. Sometimes it is hard to wash away the old glue that held the powder tray. Just cover the section with aluminum foil, trimming away the excess around the edges with the safety scissors.

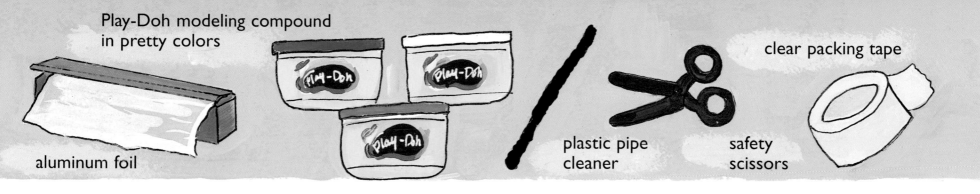

Play-Doh modeling compound in pretty colors

aluminum foil

clear packing tape

plastic pipe cleaner

safety scissors

3. Use the Play-Doh to design a pretty butterfly wing on the foil-lined side of the compact.

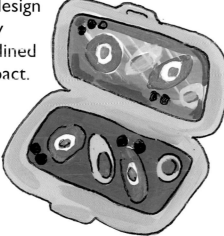

4. Wrap the pipe cleaner around the hinge of the compact and twist the ends together at one side of the compact. Spread the ends out and curl them to make antennae for the butterfly. If they seem too long, just trim them with the scissors.

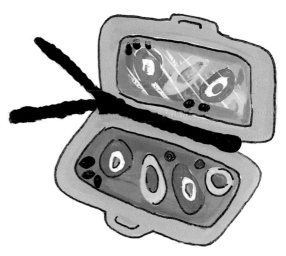

To see a butterfly that is symmetrical, hold the compact so that the wing you made is reflected in the plastic mirror on the other side of the compact. If you want to keep the pretty butterfly on your dresser for a while, cover the Play-Doh wing with clear packing tape to keep the Play-Doh from drying out.

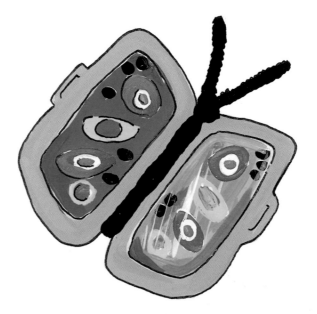

You can make Play-Doh models of your favorite creepy crawlies or design some of your own.

Creepy Crawly in a Jar

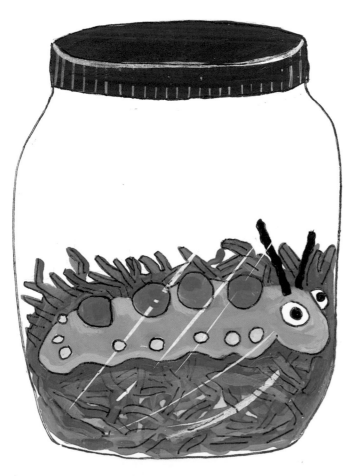

Here is what you need:

Play-Doh modeling compound in different colors

cellophane grass

Here is what you do:

1. Use the Play-Doh to make a creepy crawly to store in your jar. It can be round or elongated.

2. Make eyes for the creepy crawly using Play-Doh and add details using pieces of pipe cleaner, and tiny balls of colorful Play-Doh.

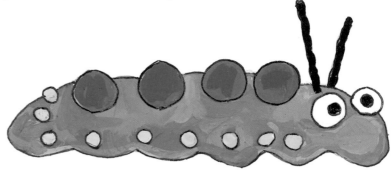

Play-Doh

plastic pipe cleaner

safety scissors

plastic peanut butter jar with lid

3. Put some cellophane grass in the jar.

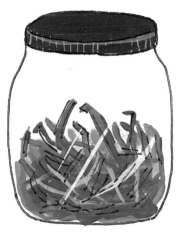

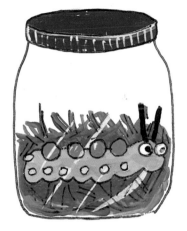

4. Put the creepy crawly in the jar and put the lid on.

Play-Doh creepy crawlies do not need air holes and food like real creepy crawlies do, so you can keep the creepy crawly in the jar for a while.

15

The rattlesnake often warns that it is about to strike by making a rattle sound with its tail.

Rattling Rattlesnake

Here is what you need:

ruler

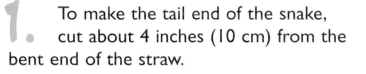

Here is what you do:

1. To make the tail end of the snake, cut about 4 inches (10 cm) from the bent end of the straw.

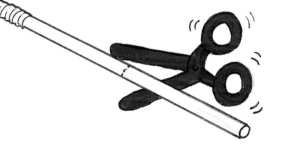

2. Stick the pipe cleaner partway into the cut end of the straw to make a frame for the body of the snake.

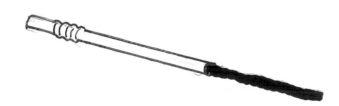

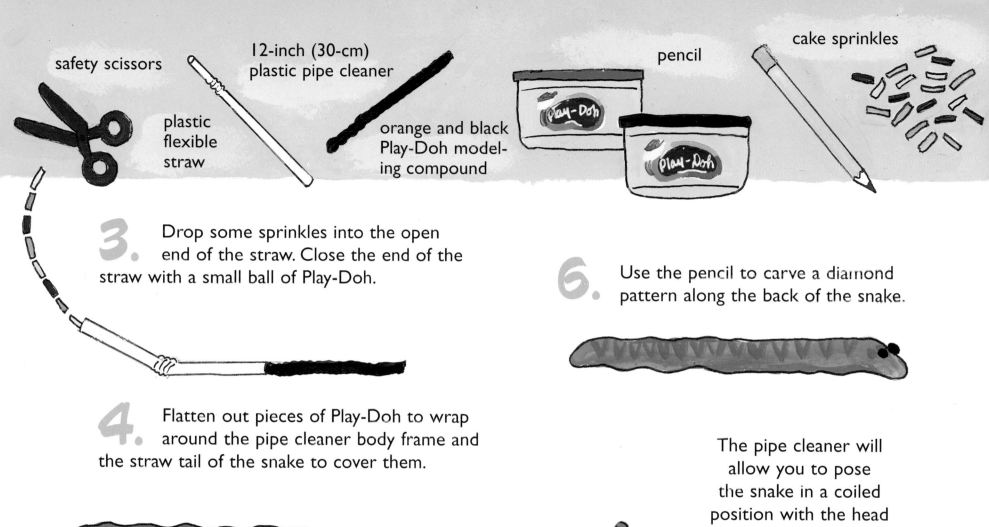

safety scissors

plastic flexible straw

12-inch (30-cm) plastic pipe cleaner

orange and black Play-Doh modeling compound

pencil

cake sprinkles

3. Drop some sprinkles into the open end of the straw. Close the end of the straw with a small ball of Play-Doh.

4. Flatten out pieces of Play-Doh to wrap around the pipe cleaner body frame and the straw tail of the snake to cover them.

5. Roll two tiny balls of black Play-Doh. Press a ball into each side of the head of the snake for eyes.

6. Use the pencil to carve a diamond pattern along the back of the snake.

The pipe cleaner will allow you to pose the snake in a coiled position with the head slightly up. Give the tail of the snake a shake to hear the warning sound of the rattle.

Sea turtles crawl up onto the beach and lay their eggs in the sand.

Sea Turtle Eggs

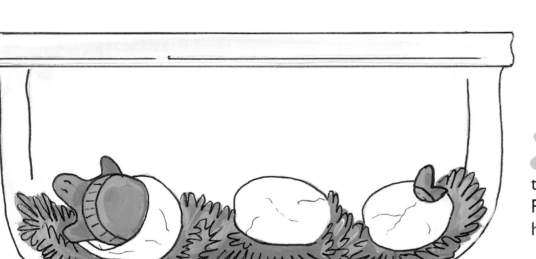

one plastic milk jug cap for each turtle

Here is what you do:

1. For each turtle, roll a ball of green Play-Doh about the size of a marble.

2. A cap will form the shell of each turtle. Flatten the ball a little bit into the cap so that some Play-Doh sticks out on the edges. Pinch the dough around the edges to form the head, tail, and the four feet of the turtle.

18

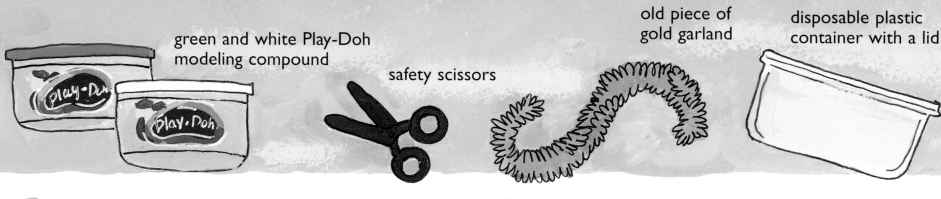

green and white Play-Doh modeling compound

safety scissors

old piece of gold garland

disposable plastic container with a lid

3. Flatten out a 1-inch (2.5-cm) ball of white Play-Doh to make the eggshell. Carefully wrap the turtle in the white Play-Doh eggshell. Use the safety scissors to trim off any excess Play-Doh. Pinch the edges to seal the eggshell.

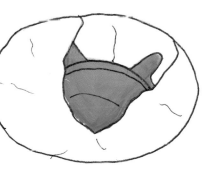

4. Make several turtles. Seal each baby turtle in a white Play-Doh "egg."

To keep the Play-Doh soft and fresh, remember to keep the lid on the container for your turtles until you decide to hatch them.

5. Put the garland in the container for "sand." Bury the turtle eggs in the sand until they are ready to hatch.

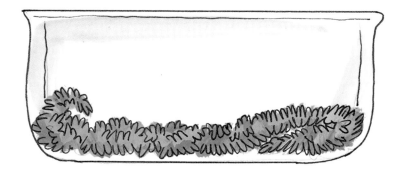

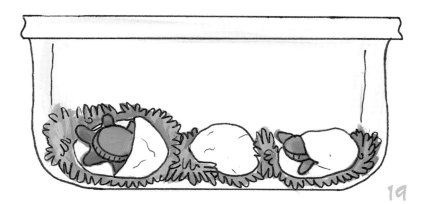

A mother crocodile carries her babies around in her mouth.

Here is what you need:

clamp clothespin

Good Mother Crocodile Puppet

Here is what you do:

1. Squeeze some green Play-Doh around the top and the bottom of the clamp clothespin to make a crocodile head. Do not pinch the top and bottom Play-Doh together. Secure the Play-Doh toward the back of the clothespin with a rubber band wrapped loosely around the Play-Doh and the clothespin. When you pinch the back of the clothespin it should look like the mouth of the crocodile head is opening.

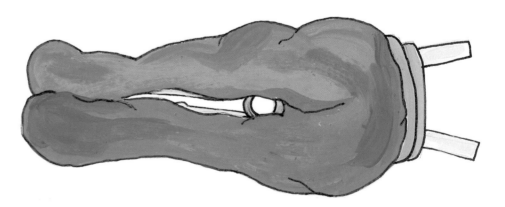

green and black Play-Doh modeling compound

rubber band

2. Roll two small balls of black Play-Doh. Press them onto the head of the crocodile for eyes.

3. Make two or three small lines of green Play-Doh to represent the babies. You can pinch out more details, such as legs, if you wish. See if the mother crocodile puppet can carry the babies around in her mouth without damaging them.

It is not easy to be a good crocodile mother!

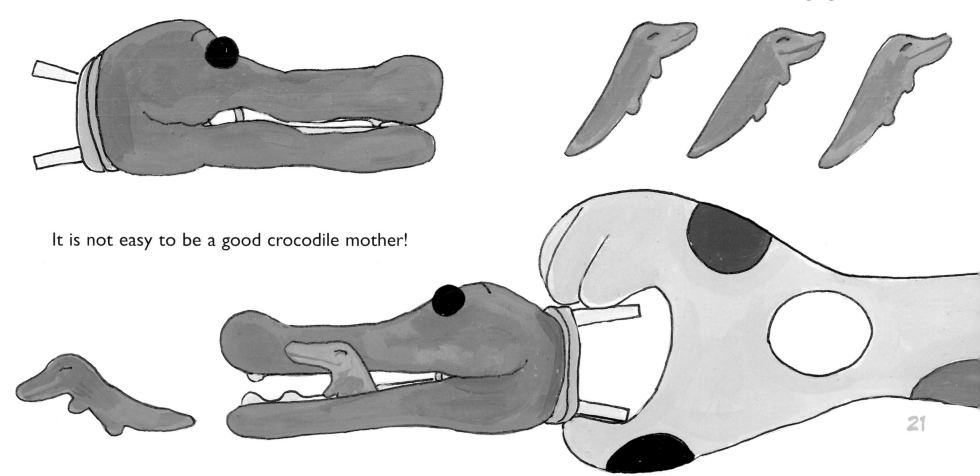

The seashells you find on the beach were once homes for various sea creatures.

Peeking Clam

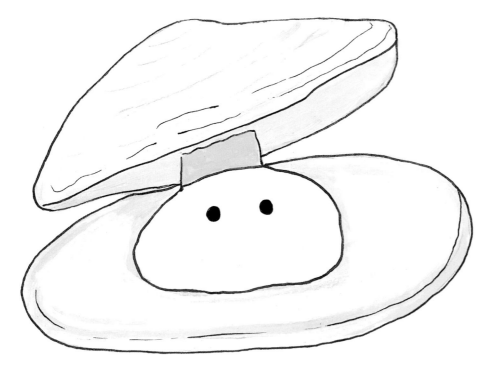

Here is what you need:

clamshell

Here is what you do:

1. If the two sides of the clamshell have come apart, make a new hinge between the top and bottom shell with a piece of masking tape. Stick one end of the tape to the top back, inside of the shell, and the other end to the bottom back, inside of the shell, to join the top and the bottom again.

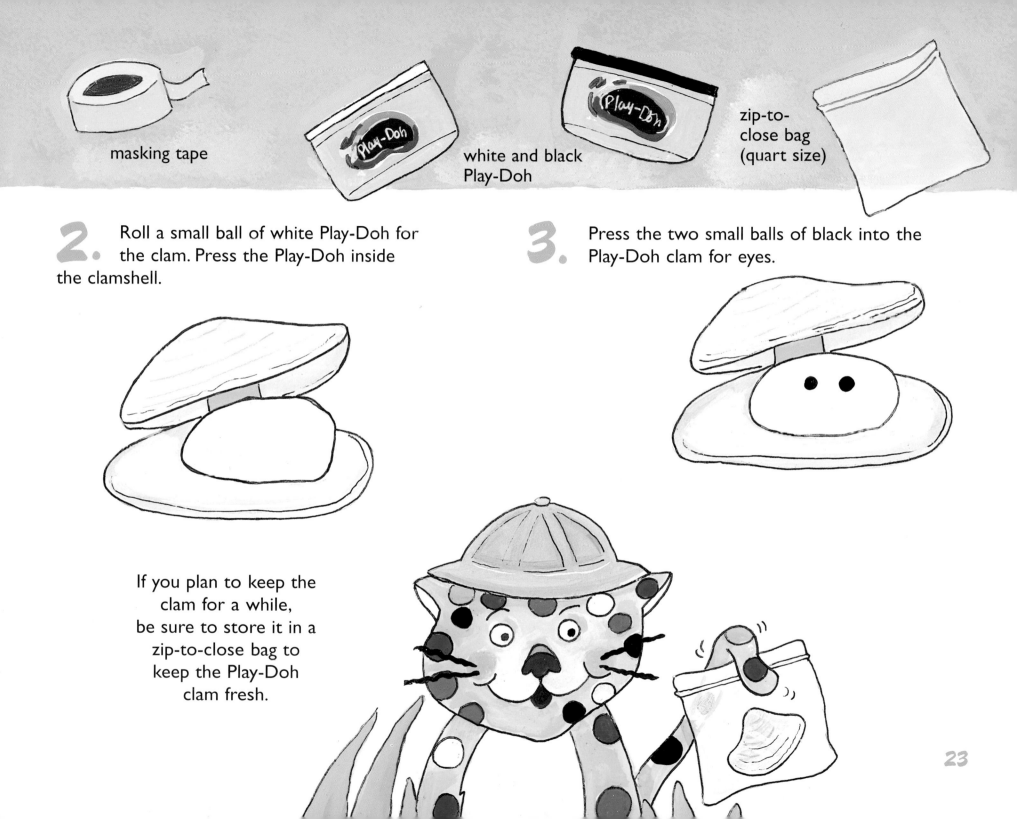

masking tape

white and black Play-Doh

zip-to-close bag (quart size)

2. Roll a small ball of white Play-Doh for the clam. Press the Play-Doh inside the clamshell.

3. Press the two small balls of black into the Play-Doh clam for eyes.

If you plan to keep the clam for a while, be sure to store it in a zip-to-close bag to keep the Play-Doh clam fresh.

23

The hermit crab moves into the empty shell of other sea creatures.

Here is what you need:

orange and black Play-Doh modeling compound

Hermit Crab

Here is what you do:

1. Roll a small "worm" of orange Play-Doh to be the body of the hermit crab. Make sure it is small enough to fit inside the shell you have chosen to use for the house.

2. Slip the crab into the shell with the end peeking out for the head.

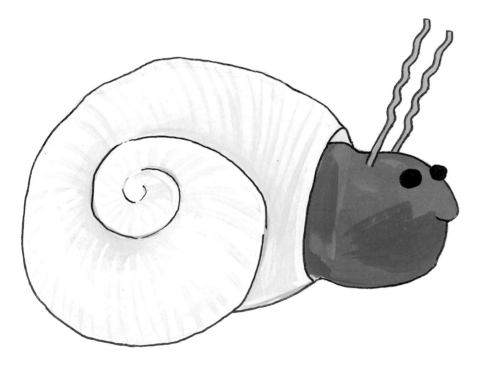

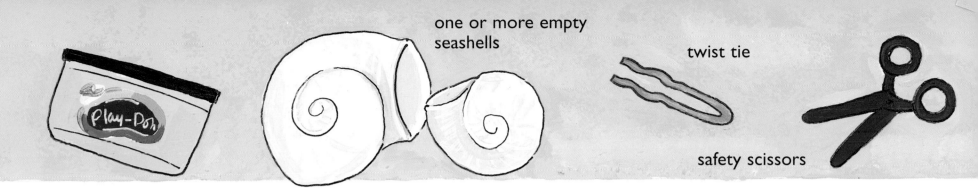

one or more empty seashells

twist tie

safety scissors

Play-Doh

3. Bend the twist tie in half and press the curved end into the top of the head for the antennae. If the antennae seem too long for the crab, use the safety scissors to trim them.

4. Press the two tiny balls of black Play-Doh into the head for eyes.

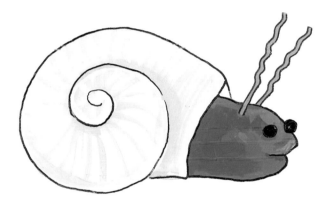

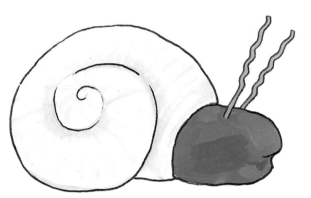

As a hermit crab grows, it needs to find a larger shell to move into. Have some extra shells on hand for the hermit crab to choose from.

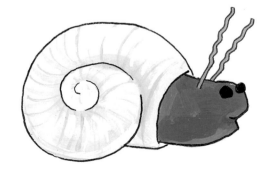

If the sea star loses an arm it can grow another one.

Here is what you need:

orange Play-Doh
modeling compound

Sea Star

Here is what you do:

1. Roll a ball of orange Play-Doh. Flatten the ball lightly with your hand. Pinch out five arms for the sea star from around the Play-Doh.

clamp clothespin

marker

2. Use the marker to draw an eye on each side of the clamp clothespin to make it look like a fish.

Swim the clothespin fish over to the sea star and make it nip off an arm. Pinch out a new arm for the sea star.

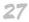

The beluga whale molts in the summer, rubbing off the shedding skin on the rough sand and gravel of the ocean bottom.

Shedding Beluga Whale

Here is what you need:

cotton balls

clear plastic soda bottle with cap

Here is what you do:

1. The bottle will become the beluga whale. Use the pencil to stuff the bottle full of cotton balls to make it look white. Put the cap on.

2. Turn the bottle on one side. Draw a face for the whale on the bottom of the bottle.

28

black permanent marker

pencil

white Play-Doh
modeling compound

piece of foam
or cardboard

old panty hose

safety
scissors

3. Flatten out chunks of the white Play-Doh. Wrap the Play-Doh around the body of the whale.

Help the beluga whale to "molt" by rubbing the whale on the rough surface to remove the outer layer of Play-Doh.

4. Make a rough surface for the whale to rub on by covering a piece of foam or cardboard with a leg cut from the panty hose. Trim off the excess stocking on each end and knot the ends to close them.

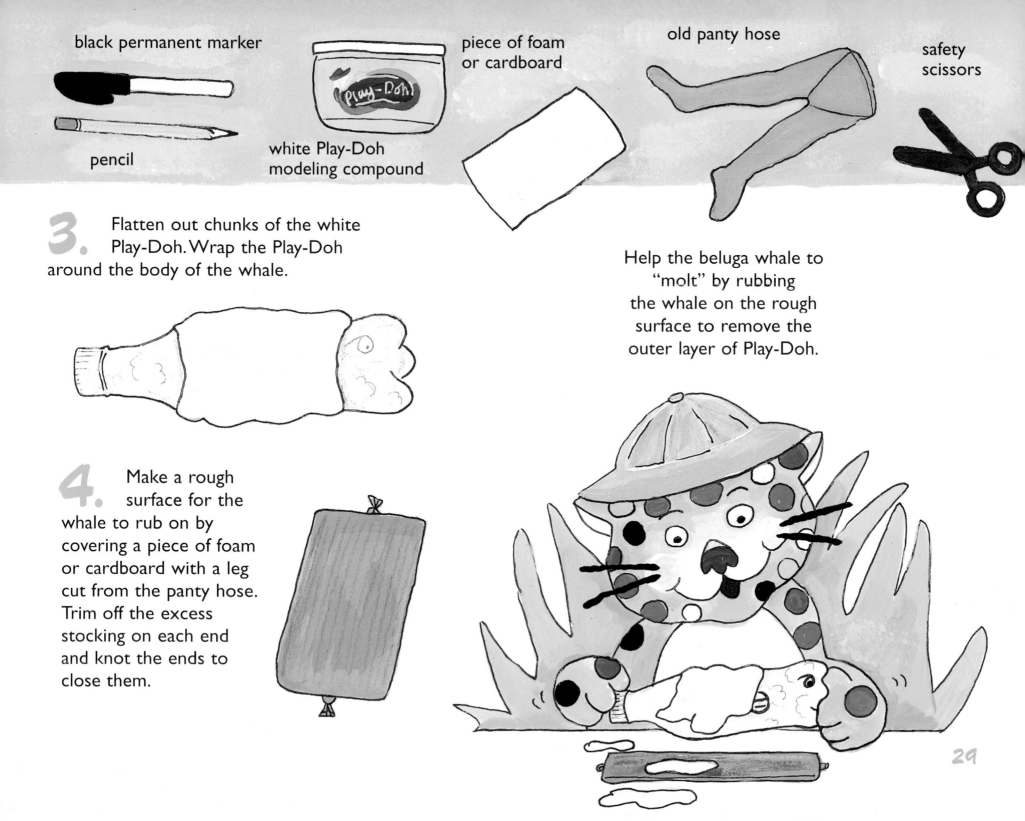

Help hatch a baby bird!

Play-Doh
modeling
compound

Bird's Nest and Egg

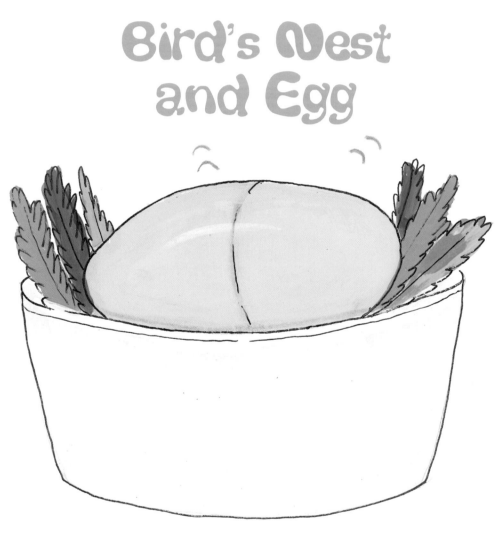

Here is what you do:

1. Use Play-Doh to shape a nest for the plastic egg in the bottom of the plastic container. Line the nest with craft feathers.

2. Roll a ball of Play-Doh small enough to fit inside the egg. Shape it to look like a baby bird by pinching out a head and two wings. Pinch a tiny beak in the head. Use the pencil to poke two eyes in the head of the Play-Doh bird.

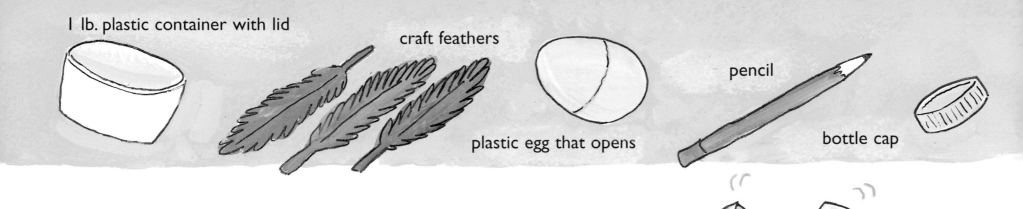

1 lb. plastic container with lid

craft feathers

plastic egg that opens

pencil

bottle cap

3. Put the Play-Doh bird inside the plastic egg. Put the bottle cap in the egg, too. Put the egg in the nest.

When you shake the egg it will sound like a baby bird pecking to get out of the egg. If you do not hatch the baby bird right away, be sure to put the lid on the container to keep the nest and bird fresh.

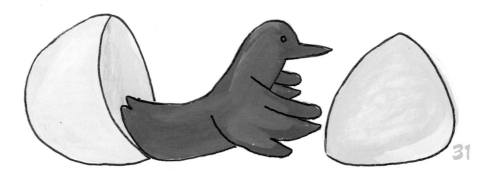

Make a Play-Doh hummingbird to fly from flower to flower, sipping nectar.

plastic flexible straw

Hummingbird Puppet

Here is what you do:

1. Squeeze some green Play-Doh around the bend in the flexible straw to make a hummingbird with the end of the straw forming the long beak.

green, black, and white Play-Doh modeling compound

red and green craft feathers

artificial flowers

2. Press two balls of white Play-Doh into the head of the bird as eyes. Put a tiny dot of black Play-Doh in the center of each eye.

3. Stick the craft feathers into the sides and back of the bird to make wings and a tail.

4. Stick each artificial flower into a ball of Play-Doh to make it stand. Arrange the flowers to make a garden for the hummingbird.

Hold the hummingbird puppet by the end of the straw to fly it from flower to flower in the garden. You might want to make the bee on page 10 to fly around your garden, too.

33

The male emperor penguin keeps the egg warm by placing it on his feet under his warm front feathers.

Here is what you need:

two cotton balls

large plastic food storage container

Emperor Penguin Family

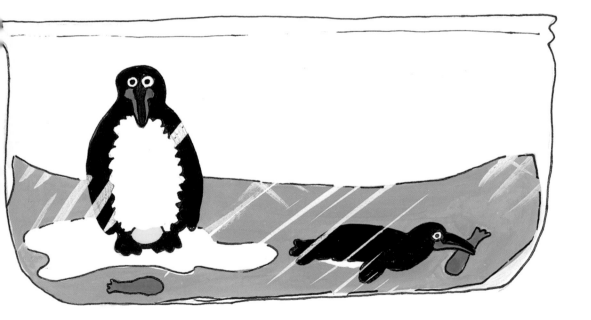

Here is what you do:

1. Shape a 2-inch (5-cm) ball of black Play-Doh. Squeeze one end into a head and long beak. Flatten two marble size balls of black Play-Doh for feet. Press the body of the penguin on the feet.

2. Add eyes by pressing two small balls of white Play-Doh to the head and adding tiny black Play-Doh dots in the center of each eye.

black, white, orange, and yellow Play-Doh modeling compound

blue cellophane

white foam tray

safety scissors

3. Add orange Play-Doh details to the penguin as shown.

4. Give the penguin a fluffy white tummy by sticking a cotton ball on the front of the penguin under the beak. Make two penguins, one to be the mother penguin and one to be the father penguin.

6. Crumple some blue cellophane for water and put it in the bottom of the container. Cut a piece of white foam to fit in one side of the container for the shore.

5. Roll a yellow Play-Doh egg for the male penguin. Place the egg on the feet of the penguin under the cotton ball so that the egg will stay nice and warm.

7. Make some Play-Doh fish to put in the water.

The mother penguin can catch fish to bring back to the father penguin, who is on the shore keeping the egg warm.

35

Prairie dogs create an incredible maze of underground tunnels.

Here is what you need:

shoe box lid

Here is what you do:

Prairie Dog Maze

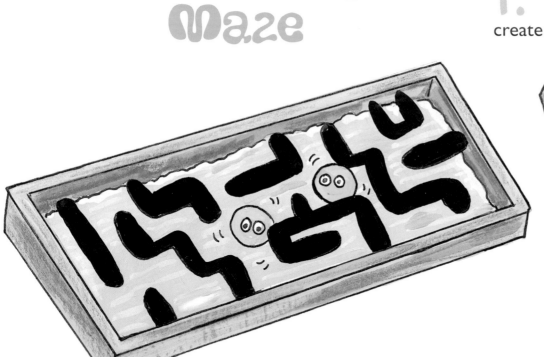

1. Cover the inside of the box lid with aluminum foil to make a nonstick surface on which to create the maze.

2. Roll some marble-sized balls of yellow Play-Doh for the prairie dogs. Press two balls of white Play-Doh onto each for eyes. Add a small dot of black Play-Doh to the center of each eye.

aluminum foil

yellow, black, and white Play-Doh modeling compound

3. Roll out long ropes of black Play-Doh to use to create the sides of the path of your maze. Turn the lid on a short side. Starting at the top left-hand corner of the lid, arrange the ropes of Play-Doh on the lid to create a maze of tunnels to roll the prairie dogs through. Don't forget to make some dead ends along the way. The maze should end up at the bottom right corner of the lid, the prairie dog's burrow.

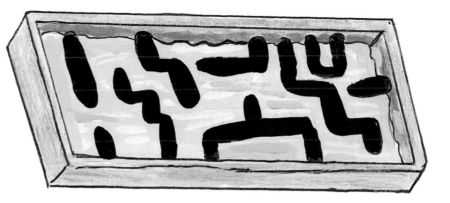

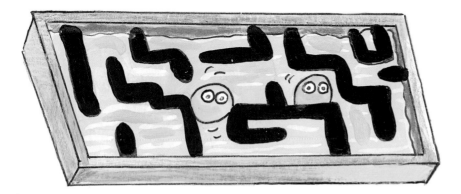

4. Put one or more prairie dogs at the top of the maze.

See if you can roll all of the prairie dogs down through the maze to their burrow. The maze can easily be rearranged to create a different one to try.

The snowshoe hare has a white coat in the winter snow that changes to brown when the snow melts.

clear packing tape

white Play-Doh modeling compound

Changing Coat Snowshoe Hare

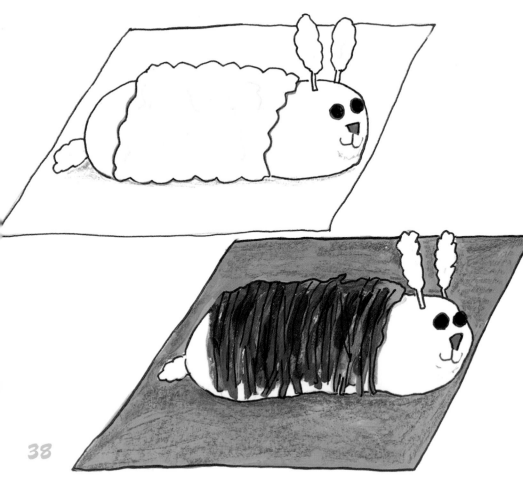

Here is what you do:

1. Shape some white Play-Doh into a 3-inch (8-cm)-long body for the hare.

2. To make a face, push small balls of black Play-Doh into one end of the body for eyes. Use the orange Play-Doh to make a little nose, and a pencil to draw the mouth.

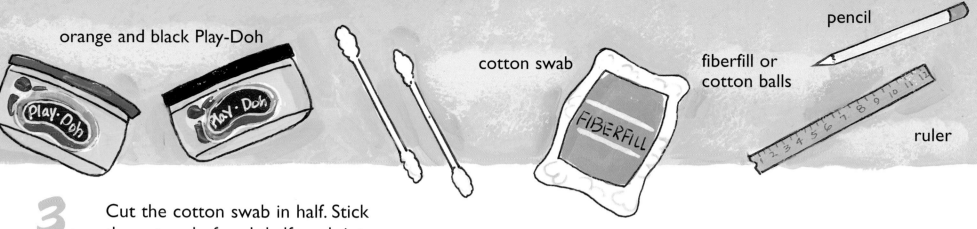

orange and black Play-Doh

cotton swab

FIBERFILL

fiberfill or cotton balls

pencil

ruler

3. Cut the cotton swab in half. Stick the cut end of each half swab into the Play-Doh above the face to make ears for the hare.

4. To make the white winter coat for the hare, tear off a 3-inch (8-cm) strip of packing tape. Cover the sticky side of the tape with fiberfill or with cotton pulled from cotton balls. Trim the fiberfill-covered tape to just fit over the top and sides of the rabbit like a coat.

39

continued on next page

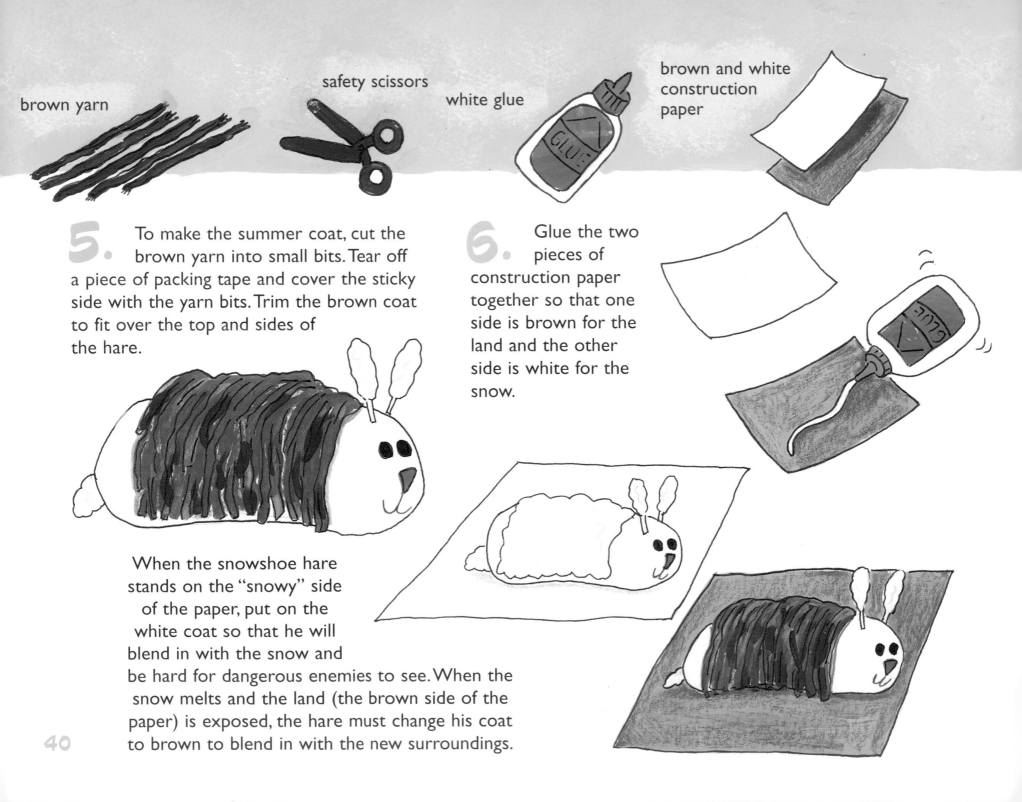

brown yarn

safety scissors

white glue

brown and white construction paper

5. To make the summer coat, cut the brown yarn into small bits. Tear off a piece of packing tape and cover the sticky side with the yarn bits. Trim the brown coat to fit over the top and sides of the hare.

When the snowshoe hare stands on the "snowy" side of the paper, put on the white coat so that he will blend in with the snow and be hard for dangerous enemies to see. When the snow melts and the land (the brown side of the paper) is exposed, the hare must change his coat to brown to blend in with the new surroundings.

6. Glue the two pieces of construction paper together so that one side is brown for the land and the other side is white for the snow.

The barbed ends of the porcupine's quills will get caught on any animal that attempts to touch the porcupine.

Here is what you need:

old stretchy knit glove

Porcupine and Dog Incident!

Ouch!

Here is what you do:

1. Roll a 2-inch (5-cm) ball of black Play-Doh for the body of the porcupine. Roll a smaller ball for the head, shaping one side of the ball into a snout. Press the head onto one side of the body.

2. Press two balls of white Play-Doh into the head as eyes. Add a tiny black Play-Doh center to each eye.

black, orange, and white Play-Doh modeling compound

spaghetti

3. Break off several 1 1/2-inch (3.75-cm) pieces of raw spaghetti for the quills. Stick the broken ends into the back of the porcupine.

4. Roll a 2-inch (5-cm) ball of orange Play-Doh for the head of the dog.

5. Press the ball on your middle finger so that it is a finger puppet.

6. The top of the ball will be the face of the dog. Use two balls of white Play-Doh for the dog's eyes. Add a tiny dot of black Play-Doh to the center of each eye. Add a nose and ears made from the black Play-Doh.

7. Put the glove on your hand for the body of the dog. Slip the head on your middle finger over the glove.

Walk your glove and Play-Doh dog over to the Play-Doh porcupine. Press the dog's nose down on the quills of the porcupine to sniff it. Pull the dog away with some quills in the nose. Ouch! This happens to "nosy" dogs quite often! You will have to help the dog get the quills out!

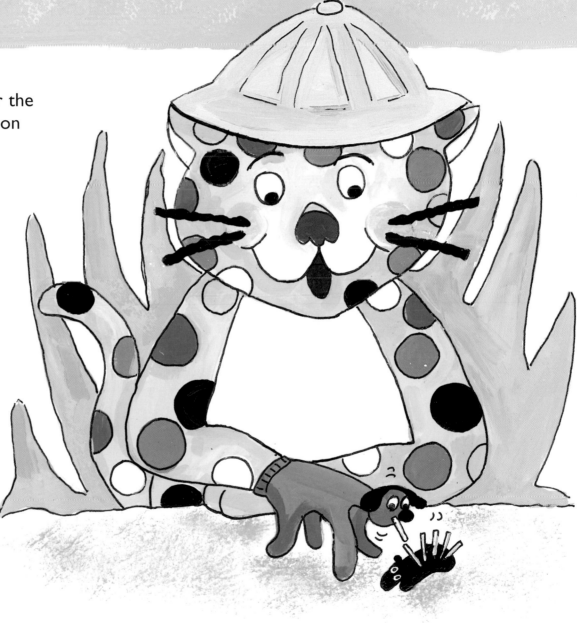

43

Play-Doh Animal Coloring

Color a favorite animal using Play-Doh.

Here is what you need:

zip-to-close bag (quart size)

safety scissors

Here is what you do:

1. Cut the black-line drawing of an animal to fit exactly inside the zip-to-close bag. Put the picture inside the bag and zip it shut.

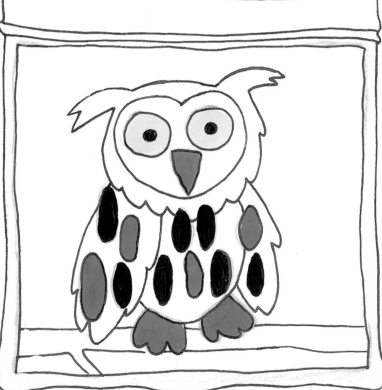

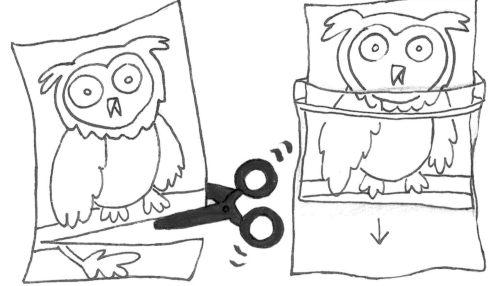

black-line pictures of favorite animals from coloring books, hand drawn, or printed off the Web

Play-Doh modeling compound

2. Use Play-Doh to create the entire shape of the animal over the drawing or to add details such as stripes and facial features.

3. If you want to save your work for a while, put it inside a second sealed plastic bag.

Collect lots of different pictures of animals to "color" with Play-Doh.

Create your own animal faces
with this project.

frozen juice can lid with rolled edges

Changing Animal Faces Magnet

Here is what you do:

1. The metal lid will be the head for the changing animal face. Put a piece of sticky-back magnet on the back of the lid.

46

Play-Doh modeling compound

clear packing tape

strip of sticky-back magnet

safety scissors

2. Shape different animal eyes, ears, and noses from the Play-Doh. Press each feature onto a piece of sticky-back magnet.

If you create a face you want to keep for a while to hang on the refrigerator, wrap the front of the face with clear packing tape, being careful not to cover up the magnet piece on the back. Use the scissors to trim off any excess tape.

3. Create different animal faces on the lid by arranging and rearranging the various features.

47

About the Author and Artist

During her thirty years as a teacher and director of nursery school programs in upstate New York, Kathy Ross has used a *lot* of Play-Doh modeling compound!

She is the author of more than forty craft books for young children, among them The Holiday Crafts for Kids series, and *Crafts For All Seasons, Christmas Crafts To Give As Gifts,* and *Crafts From Your Favorite Children's Songs.*

A graduate of Pratt Institute, Sharon Vargo lives near Indianapolis, Indiana, with her husband and four teenage sons. Ms. Vargo is the author/illustrator of *Señor Felipe's Alphabet Adventure,* and the illustrator of another Kathy Ross book, *Make Yourself A Monster.*

Kathy and Sharon have collaborated on another Play-Doh craft book, *Play-Doh Art Projects.*